CAPE TOWN

GERALD HOBERMAN

CAPE TOWN

GERALD HOBERMAN

Photographs in celebration of
'the fairest cape we saw in the whole circumference of the earth'

SIR FRANCES DRAKE 1580

Text by Roelien Theron

THE GERALD & MARC HOBERMAN COLLECTION

CAPE TOWN • LONDON • NEW YORK

Photography and production control: Gerald Hoberman

Design: Gerald Hoberman, Marc Hoberman, Roelien Theron, Christian Jaggers

Text: Roelien Theron

Cartography: Peter Slingsby

Mighty Marvelous Little Books are published by
The Gerald & Marc Hoberman Collection
PO Box 60044, Victoria Junction, 8005, Cape Town, South Africa
Telephone: 27-21-419 6657 Fax: 27-21-418 5987
e-mail: office@hobermancollection.com
www.hobermancollection.com

International marketing, corporate sales and picture library
Hoberman Collection (USA), Inc. / Una Press, Inc.
PO Box 880206, Boca Raton, FL 33488, USA
Telephone: (561) 542 1141 e-mail: hobcolus@bellsouth.net

ISBN 1–919734–52–X

First published 2002, Reprinted 2002, 2005

Printed in Singapore

DISTRICT SIX

CONTENTS

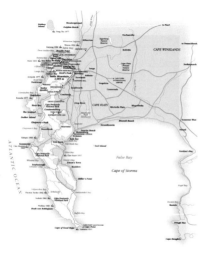

N

CAPE TOWN

INTRODUCTION

Cape Town is unrivalled for its scenic splendour. This scintillating jewel at the southern tip of the African continent, with its rich flora and fauna and vibrant cultural fusion, is a very special place. The city is set in an amphitheatre of spectacular mountains. Flat-topped Table Mountain, with its world-famous cableway, is flanked by Devil's Peak, Lion's Head and Signal Hill. On the Atlantic seaboard the majestic Twelve Apostles stand sentinel. Nearby is the magnificent Chapman's Peak. At the southernmost tip of the Cape Peninsula lies Cape Point, a

craggy promontory whose steep cliffs are lashed by wild currents and treacherous seas. From here in the direction of Cape Agulhas, the Indian and Atlantic Oceans meet.

The peninsula is fringed with pristine, white sandy beaches. It has dramatic sunsets and a Mediterranean climate, fanned by gentle ocean breezes. These breezes contribute to the success of the renowned vineyards along the picturesque wine route. On occasion a howling wind changes the mood as the southeaster, affectionately known as the Cape Doctor, delivers fresh clean air.

Cape Town's historic dockland, the Victoria and Alfred Waterfront, has excellent restaurants, cafés, hotels,

craft markets, curio shops, cinemas and shopping malls. It boasts an aquarium and a helipad, as well as a conference centre, a university campus, a marina and luxury apartments. Small wonder that Cape Town is regarded as a premier tourist destination!

I am delighted to share these 'magic moments' with you in this little book. It is a memento, a record and a celebration of life in Cape Town at the dawn of the 21st century.

Gerald Hoberman

GERALD HOBERMAN
Cape Town

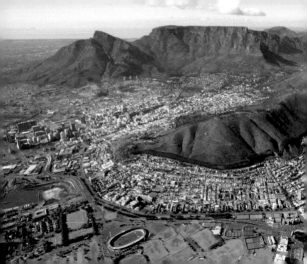

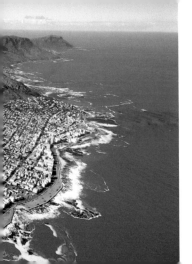

Fairest Cape

'We ranne hard aboard the cape, finding report of the Portugals to be most false.... This cape is the most stately thing and the fairest cape we saw in the whole circumference of the earth.' (Sir Francis Drake, 1580)

Victoria and Alfred Waterfront

At the water's edge lies the Victoria and Alfred Waterfront, a vibrant mix of Victorian dockland and contemporary urban design set amidst the hurly-burly of a working harbour. Rescued from a state of disrepair in the early 1990s, the buildings of the historic Victoria and Alfred Basins were converted into malls, hotels, restaurants, taverns and markets to provide a unique, all-week shopping and entertainment experience.

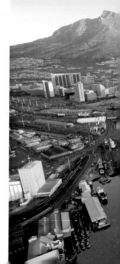

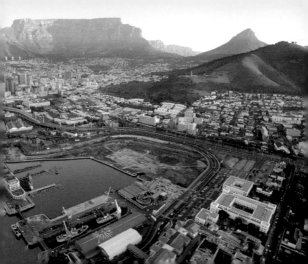

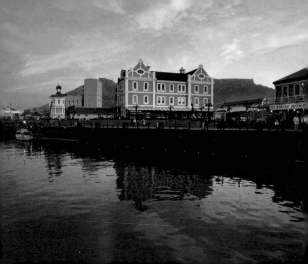

OLD PORT CAPTAIN'S OFFICE BUILDING

The Old Port Captain's Office Building, now handsomely restored, was built in 1904, when the harbour was expanding rapidly. The gabled building stands next to the 'Cut' at the entrance to the Alfred Basin, and replaced the first Port Captain's Office, the nearby octagonal, Gothic-style Clock Tower built in 1882 and used as a lookout by shipping controllers and berthing staff. The Clock Tower housed the only tide gauge on the coast at the time.

JAZZ AT THE WATERFRONT

One of Cape Town's premier shopping destinations, the Victoria and Alfred Waterfront is also one of its main entertainment centres. During the summer street musicians entertain visitors with their own brand of Cape jazz, a main ingredient in the musical mix offered at the Waterfront. The year starts off with the annual four-day Jazzathon, showcasing some of the city's finest talents, and ends with the Sunsetter Festival, during which the cream of local musicians perform a wide range of music styles, from jazz and blues to kwaito and acoustic rock.

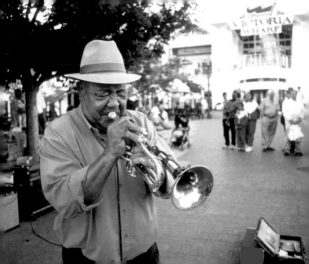

ROBBEN ISLAND

Robben Island was used as a posting station by passing ships from the 16th century, and by subsequent governments as a prison. During the 19th century, able-bodied prisoners were transferred to the mainland, and the prison population on the island increasingly came to consist of the infirm. Robben Island later became a leper colony. During World War II it was part of South Africa's coastal defences. In 1960 it became a high-security prison for those who opposed apartheid. Today this World Heritage Site is a museum and nature reserve.

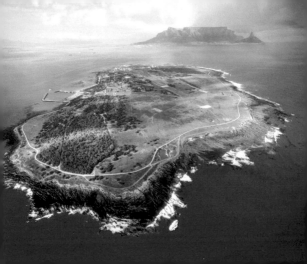

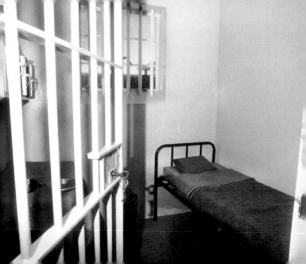

NELSON MANDELA'S CELL

In 1964 the Rivonia trialists, including Nelson Mandela, Walter Sisulu, Govan Mbeki and Ahmed Kathrada, were convicted of treason and sentenced to life imprisonment on Robben Island, then a maximum-security prison for political prisoners. As prisoner 488/64 and once the world's most famous inmate, Nelson Mandela spent 18 of his 27 years of incarceration on Robben Island. During that time the island became known as 'the university', as inmates ran a system of classes and tutorials to debate both political philosophy and practical tactics.

AFRICAN PENGUINS

Africa's only indigenous penguin, the African or jackass penguin is found along the southwestern coastal regions of southern Africa and on offshore islands. Their numbers have been severely depleted by overfishing, commercial exploitation of penguin eggs, guano removal from islands and oil pollution. Although the penguin is listed as a vulnerable species, sizable populations can be found at Boulders beach, along False Bay, and on Robben Island.

Overleaf *Table Mountain viewed from Bloubergstrand.*

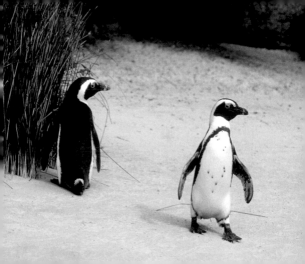

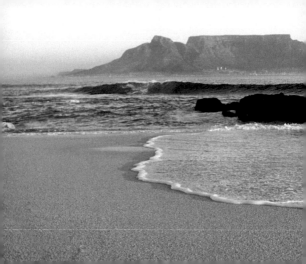

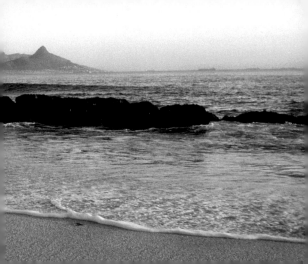

TABLE MOUNTAIN

Rising dramatically out of the Atlantic, Table Mountain, a massif of granite, sandstone and shale, stands as a beacon of safe harbour. For early European travellers, the famous mountain represented a welcome mid-point on the trade route between home and the East. It was a place where supplies could be replenished and preparations made for the final leg of the journey. It has always been invested with a spiritual significance, and today some esoteric philosophies claim that Table Mountain is a powerful world energy site.

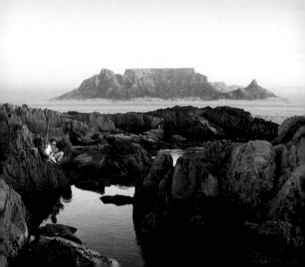

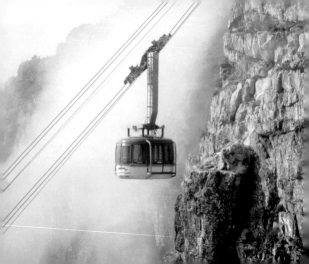

CABLEWAY, TABLE MOUNTAIN

The idea of a system of public transport to the top of the 1,085-metre-high Table Mountain was first mooted before World War I, and in 1913 the city council, on the advice of a Swiss expert on mountain railways, allocated funds for a cableway up Platteklip Gorge. Construction began in 1927, and the first official journey was undertaken in 1929. In the late 1990s the cableway was renovated to accommodate the increasing numbers of visitors — more than 450,000 per year — to Cape Town's most famous landmark.

CAPE POINT

Cape Point is a rocky promontory at the end of the mountain chain of the Cape Peninsula; it points south and east, towards Cape Agulhas, the southernmost tip of Africa. There are two lighthouses at Cape Point: the older one, built in 1859, was wrongly positioned – the light was enveloped by fog much of the time. After the Portuguese ship, the *Lusitania*, was wrecked in 1911 on Bellows Rock off Cape Point, a new lighthouse was built on the lower cliffs. It is the most powerful lighthouse on the South African coast, with a range of 63km.

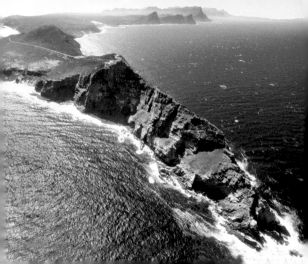

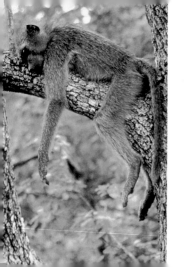

Chacma baboon *Four chacma baboon troops are found near Cape Point in the Cape Peninsula National Park, making these baboons the world's most southwesterly-dwelling primates (other than humans). Uniquely, one troop ranges along the coast, where its members forage for shellfish.*

Cape eagle owl *A nocturnal bird of prey, the large Cape eagle owl lives a secluded life, mainly in mountains, hills and rocky outcrops. In the southwestern Cape it also inhabits vegetation types such as fynbos, preferring to frequent rocky ledges in these habitats.*

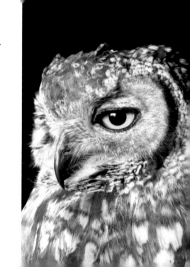

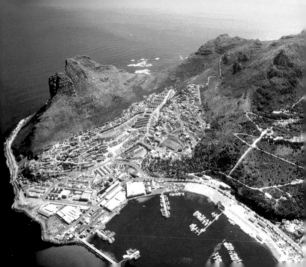

HOUT BAY

An inspiring amphitheatre of mountains surrounds the tranquil valley of Hout Bay. The Sentinel, in a timeless vigil, stands serenely at the entrance to the bay, keeping watch over an ocean that stretches 8,000km south toward the Antarctic. Across the inlet, the cliffs of Chapman's Peak plunge steeply into the sea. The bay once served as a temporary port for vessels unable to brave the storms off Cape Point. Today the busy Hout Bay harbour is the centre for Cape Town's tuna and crayfishing industries.

ATLANTIC SEABOARD AT SUNSET

It was Sir Frederick de Waal's vision of a circular scenic road around the Cape Peninsula that brought into being some of the most stunning coastal drives in the world. Elected as Cape Administrator in 1910, De Waal set in motion a plan to link the city with Wynberg, Simon's Town with Cape Point and Sea Point with Hout Bay. The opening of the spectacular Chapman's Peak, between Hout Bay and Noordhoek, in 1922 saw the fulfilment of De Waal's dream to create something that 'was not a road of necessity at all, but entirely and solely a road of pleasure'.

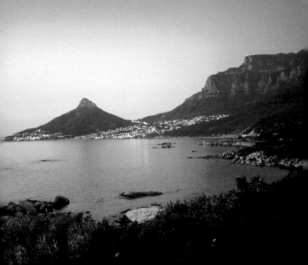

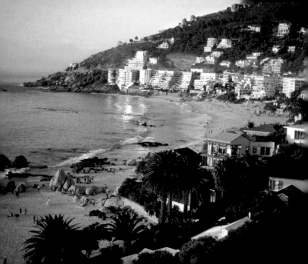

CLIFTON

Every summer, hundreds of sun lovers flock to Clifton, Cape Town's most glamorous quartet of beaches. Huge granite boulders divide the beach into separate coves. According to local custom, the largest of the beaches, Fourth beach, is favoured by families, while First, Second and Third are frequented by teenagers and twenty- to thirty-somethings. Along the rim of Clifton lies some of the city's most coveted real estate. Originally built during World War I as temporary housing, the seaside bungalows have since been converted into stylish homes.

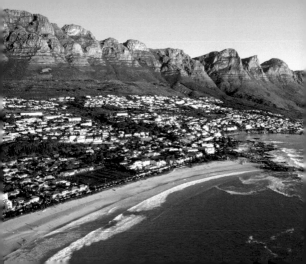

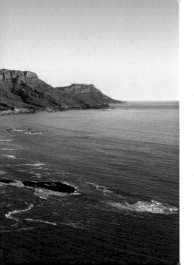

Camps Bay

Popular Camps Bay lies at the foot of the Twelve Apostles, the legendary buttresses of Table Mountain. Camps Bay boasts fine restaurants, a thriving theatre, and one of the best settings for a sunset picnic.

SOUTHERN RIGHT WHALES

At the end of every autumn, southern right whales journey from their feeding-grounds in the Antarctic to the warmer waters of the Cape where they mate, calve and rear their young. In earlier times these whales were regarded as the 'right' kind to hunt: they provided high-quality oil and baleen, were easy to harpoon, and their bodies could be retrieved for processing. Declared a protected species in 1935, their numbers have slowly increased. The Cape waters are renowned for offering the best land-based whale-watching in the world.

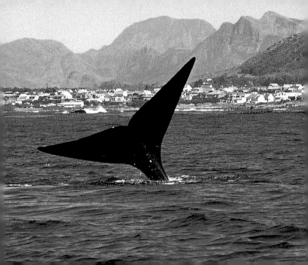

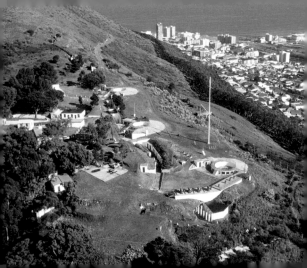

NOON GUN

At noon, every week from Monday to Saturday, the city bowl reverberates with the sound of an 18-pounder gun situated at Lion Battery on the slopes of Signal Hill. The tradition began in 1807 to enable passing ships to measure the accuracy of their chronometers. The noon gun is one of Cape Town's five surviving 18-pounders cast in England during the reign of King George III (1760–1820). During both World Wars a two-minute silence was observed at the sound of the noon gun to remember the men at the front.

BO-KAAP

The Bo-Kaap (Malay Quarter) lies above the city on the slopes of Signal Hill. The first homes were built here in the 1760s and were rented by people of European descent. The influx of Muslims to the area coincided with the building of the Bo-Kaap's first mosque, the Auwal Mosque, in 1795. Its founder, Tuan Guru, came to the Cape as a political prisoner from Tidore in Indonesia in 1780. By 1840, several mosques had been built in the neighbourhood and after the emancipation of the slaves in 1834, many Muslims chose to settle near their places of worship.

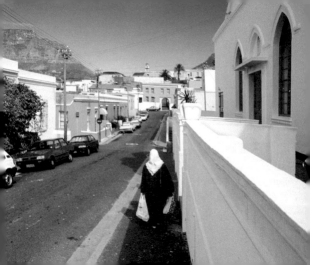

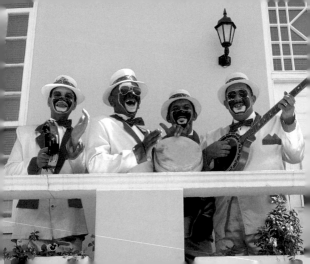

CAPE CARNIVAL

The Cape Minstrel Carnival has its roots in the music and dance style of North American minstrel groups who visited the Cape in the late 1880s. The first three days of the new year is carnival time: Cape Town's streets are transformed into a kaleidoscope of colour, as the *Kaapse Klopse* (minstrels) cavort through the city, singing *moppies* (humorous songs) and dancing to the sounds of banjos, tubas, guitars, guma drums and whistles. The partying lasts for days, and the festivities continue for a month, as clubs compete for various trophies at a range of city stadiums.

Long Street *Ornate cast-iron railings in various styles — mass-produced following the industrial revolution in the mid-19th century — adorn the balconies of the many Victorian buildings in historic Long Street.*

Right *Mural, Upper Orange Street.*

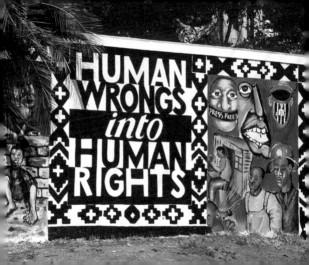

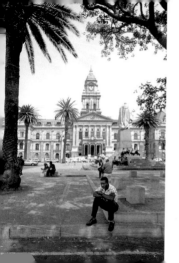

City Hall *The ornate Italian Renaissance-style City Hall was completed in 1905. It faces the Grand Parade, where more than 100,000 people gathered on 11 February 1990 to hear Nelson Mandela give his first public address after spending 27 years in prison.*

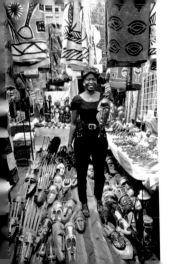

Green Market Square

Buzzy and bright, Greenmarket Square is a treasure trove of exotic and original wares. Once a fruit and vegetable market, the cobblestoned square dates back to 1696 when it served as a forecourt to the Burgher Watch House (now the Old Town House).

CAPE TOWN CASTLE

The original castle of Cape Town was an earth fort commissioned by Jan van Riebeeck. The present castle was built between 1665 and 1676, and is one of the oldest European structures in southern Africa. Its unusual pentagonal shape was pioneered by Sébastien de Vauban, Louis XIV's military engineer. The design became popular in defensive military architecture, and is the basis of the Pentagon, the US Defense Department headquarters.

Overleaf *Government Avenue, Company's Garden.*

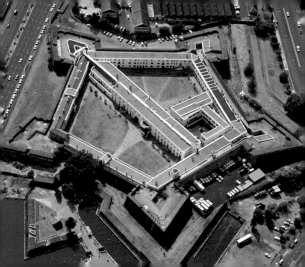

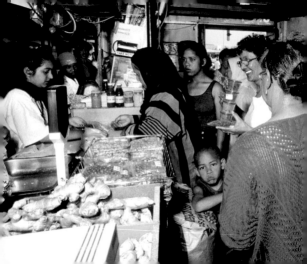

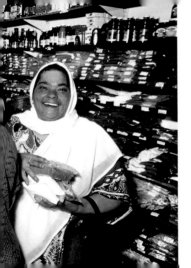

Spice of life

Stacked from floor to ceiling with pungent spices and seasonings integral to Indian and Malay cuisines, Osman's spice shop in Rylands is as renowned today as it was forty years ago, when it traded in District Six.

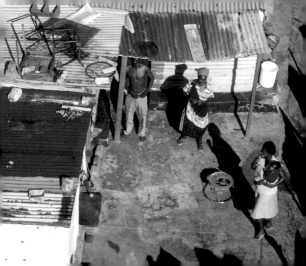

INFORMAL SETTLEMENTS

In a city renowned for its breathtaking beauty and great cultural diversity, Cape Town's townships are increasingly becoming drawcards for international visitors eager to venture off the beaten track and experience life on the Cape Flats. Organised tours of Langa, Guguletu and Khayelitsha include visits to traditional healers, shebeens (taverns), flea markets, arts and crafts centres, jazz venues and museums, while overnight stays in B&Bs, and even shack dwellings, provide guests with a glimpse of township culture and a taste of local cuisine.

ZAMA ZAMA CASH STORE

While some entrepreneurs show their flair in the board-room, others have become master street traders, filling pavements and city squares with their colourful wares and the sound of their friendly bartering. Independent and creative entrepreneurs have surfaced in nearly all of Cape Town's informal settlements, and there is hardly a street that doesn't have its own spaza shop. Prices are not always competitive, but paying them is preferable to taking a taxi to the nearest chain store, which can be up to 30km away. Zama Zama, appropriately, means try and try again.

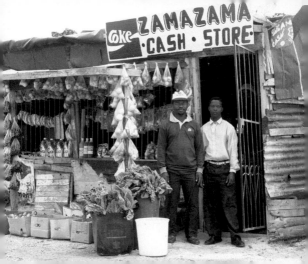

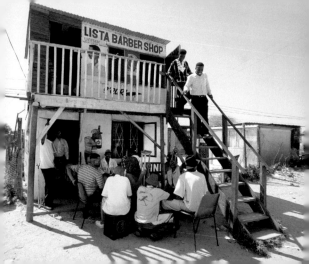

LISTA BARBER SHOP AND MINI TAVERN, KHAYELITSHA

Lista Barber Shop and Mini Tavern houses the smallest tavern in the world. Although the tavern has only one table and a couple of chairs, up to 60 patrons can be found here on some weekend nights. Upstairs three barbers are employed to cut and shave hair in the latest styles, called S'Curl, Relaxer, Mushroom or German Cut. Lista's achieved international fame when it was the subject of a German television documentary in 1996.

CROSSROADS

Almost half of South Africa's citizens are under the age of 20, and many of them live in squatter settlements in and around major cities. Crossroads, one of Cape Town's oldest informal settlements, was established in 1975. Here, despite stark surroundings, a burgeoning optimism reigns. Everywhere there are signs of simple human dignity and an irrepressible will to survive: small gardens, one with a flourishing tree, take root in near-infertile soil; shacks provide basic shelter; and a preschool offers young children a vital start in life.

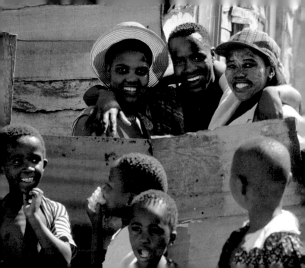

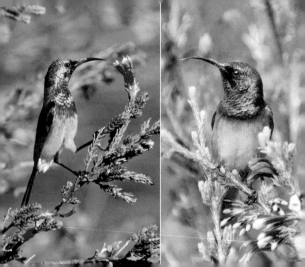

SUNBIRDS

The lesser doublecollared sunbird *(left)* is a common inhabitant of mountains, forests and urban gardens in the Western Cape and along the eastern coast. As with all sunbirds, its slender, curved bill is uniquely adapted to reach deep within flowers, such as the tubular-shaped ericas. Found mainly in mountainous areas, the tiny orangebreasted sunbird *(right)* enjoys a symbiotic relationship with ericas and proteas, which it pollinates as it moves from flower to flower. The male is iridescent, while the female has an overall greenish-yellow colour.

KING PROTEA

Beautiful and regal, the king protea *(Protea cynaroides)* is South Africa's national floral emblem. Its compound flower head consists of an involucre (cup) of coloured sterile bracts, enclosing between 250 and 600 individual flowers. Common on mountains ranging from the Cederberg to Grahamstown, the king protea is found at different altitudes and in diverse habitats. In every locality the plants consist of distinct variants, each genetically programmed to flower at different times, making it possible to find a bloom every single day of the year.

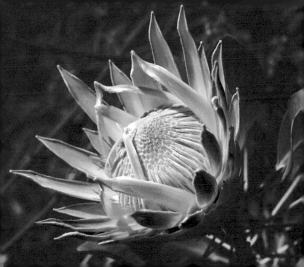

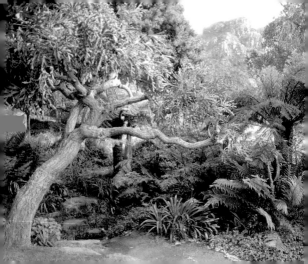

Kirstenbosch *The botanical garden, on the eastern slopes of Table Mountain, is mainly devoted to indigenous plants, including some of the 8,500 species of fynbos that make up the unique Cape floral kingdom.*

Kirstenbosch National Botanic Garden

A section of the wild almond hedge planted by Jan van Riebeeck in 1660 can still be seen at Kirstenbosch. Established in 1913, Kirstenbosch, with its dramatic mountain setting, ranks as one of the great botanic gardens of the world.

Mostert's Mill *A familiar sight on Rhodes Drive, Mostert's Mill is the oldest surviving windmill in South Africa. Built in 1796 on the farm Welgelegen, it fell into disuse in the 19th century, but was restored to working order by a millwright from Holland in the 1930s.*

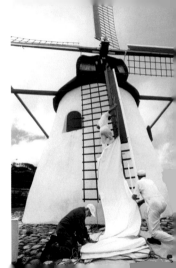

GROOT CONSTANTIA

Groot Constantia, with its magnificent Cape Dutch homestead, enjoys a reputation as one of the country's finest wine estates. The famous wine farm dates back three centuries when Cape Governor Simon van der Stel planted the first vineyards in the fertile Constantia valley. But it was really after Hendrik Cloete acquired Groot Constantia in 1778 that its wines began to attract an international following. Napoleon Bonaparte, King Louis Philippe of France and Emily Brontë were among its early clientele.

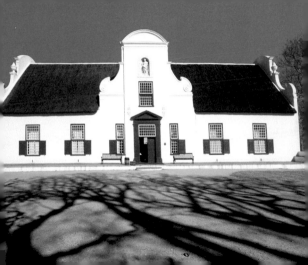

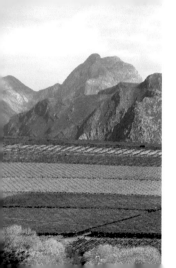

Hex River valley *The spectacular Hex River valley, with its fertile soil and crystal clear streams, produces some of the Cape's sweetest table grapes and finest export wines. The first vines in the Cape were planted in the Company's Garden by Jan van Riebeeck in 1655.*

Franschhoek *Set in a spectacular vine-clad valley, Franschhoek ('French corner') is popular with visitors and locals alike, who come here to enjoy its unrivalled mountain scenery, fine French cuisine and Cape wines.*

Overleaf *Helshoogte Pass, Cape winelands.*

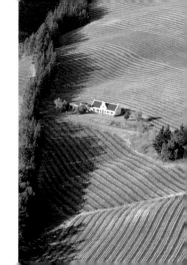

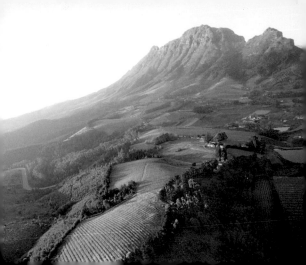